This book is dedicated to my angel Stella. Always follow your dreams my darling.

THIS BOOK BELONGS TO:

WITH LOVE FROM:

F is for Fashion
published in 2019 by
PS Publishing
313 NE 3rd Street
Delray Beach, FL, 33444
www.pspublishing.co
www.fisforfashionbook.com

Library of Congress Control Number: 2019948355

ISBN 978-1-7334268-0-0

Illustrated digitally
Designed by Amanda Perna & Solomon Strul

Printed in China
1 2 3 4 5 6 7 8 9 10

PS Publishing books are available at special discounts when purchased
in quantity for premiums and promotions as well as fundraising or
educational use. Special editions can also be created to specification.
For details, contact info@pspublishing.co.

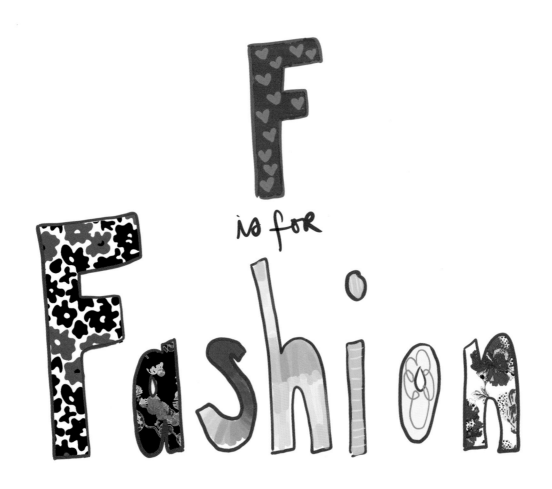

F is for Fashion

Written By Amanda Perna + Solomon Strul

Illustrated By: Amanda Perna

PS PUBLISHING

io for A-line (dress)

a is for a-line (dress)

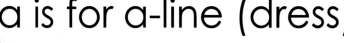

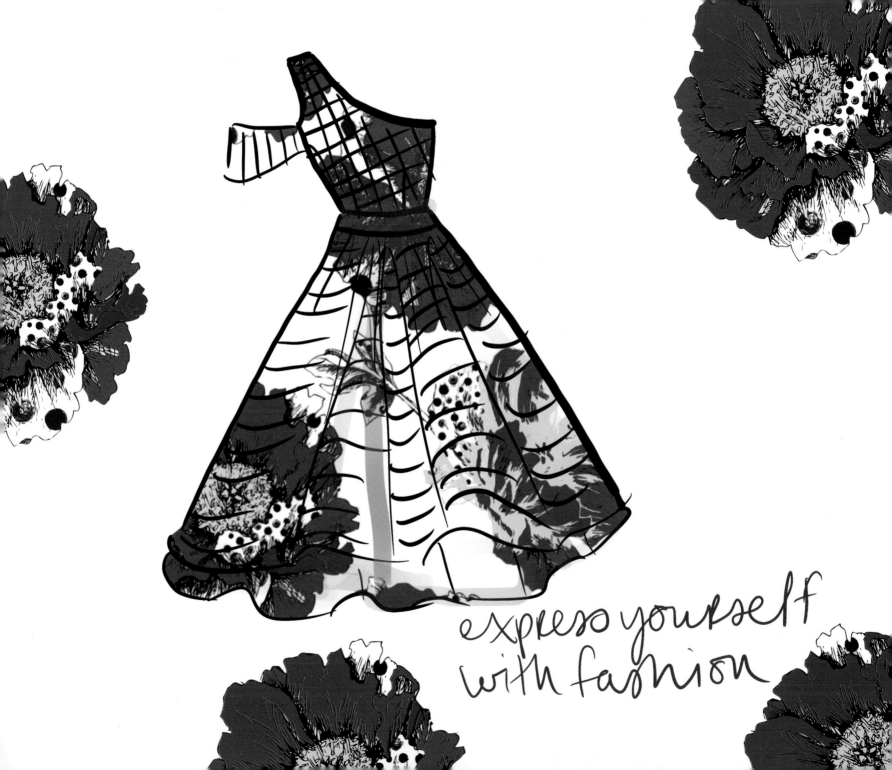

express yourself
with fashion

Bb

io for bathing suit

b is for bathing suit

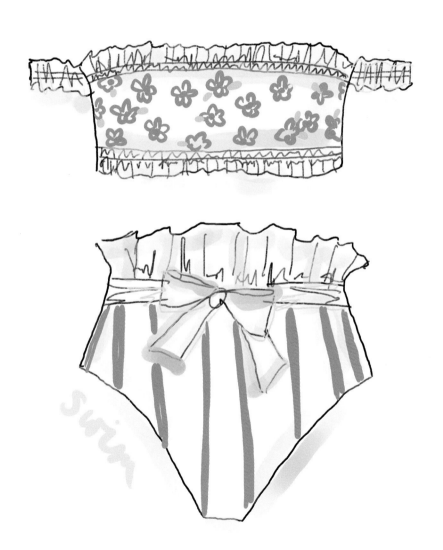

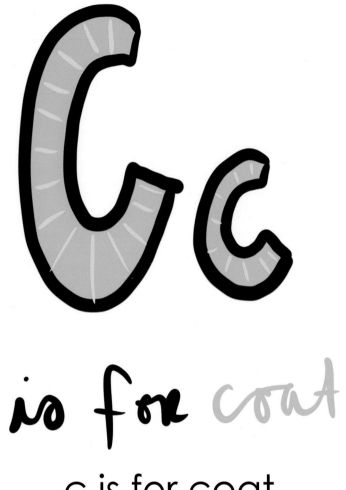

is for coat

c is for coat

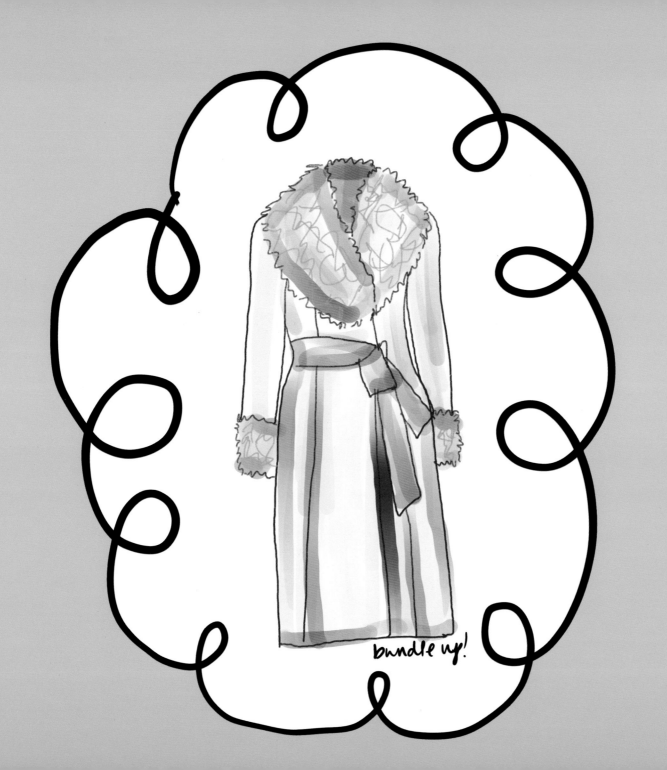

bundle up!

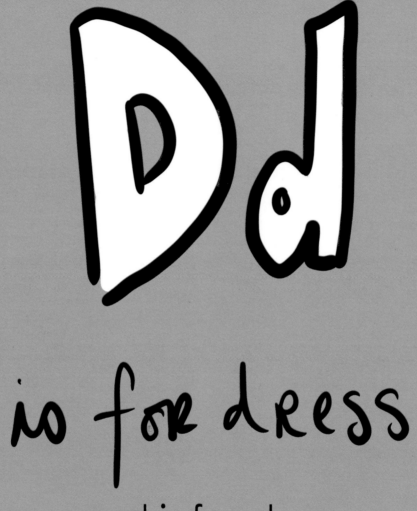

is for dress

d is for dress

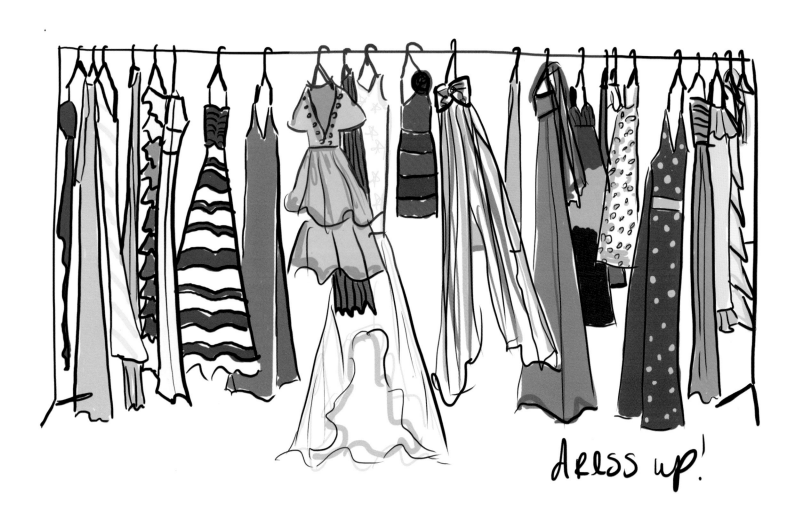

dress up!

E e

io for earring

e is for earring

tassels, pompoms, studs, opals, hoops, beads,

crystals, wood, diamonds, lunis, opals

Ff

is for fashion

f is for fashion

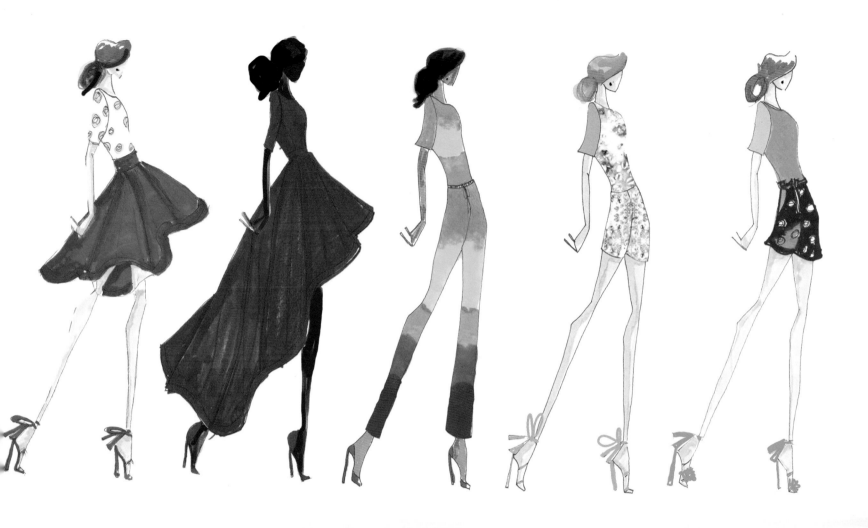

the world is your runway

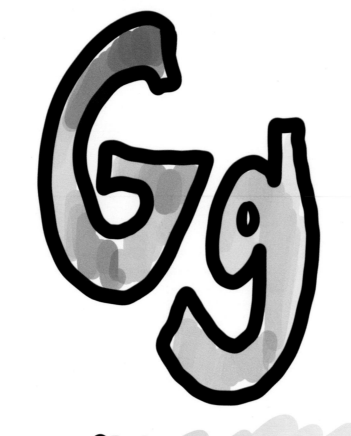

is for glasses

g is for glasses

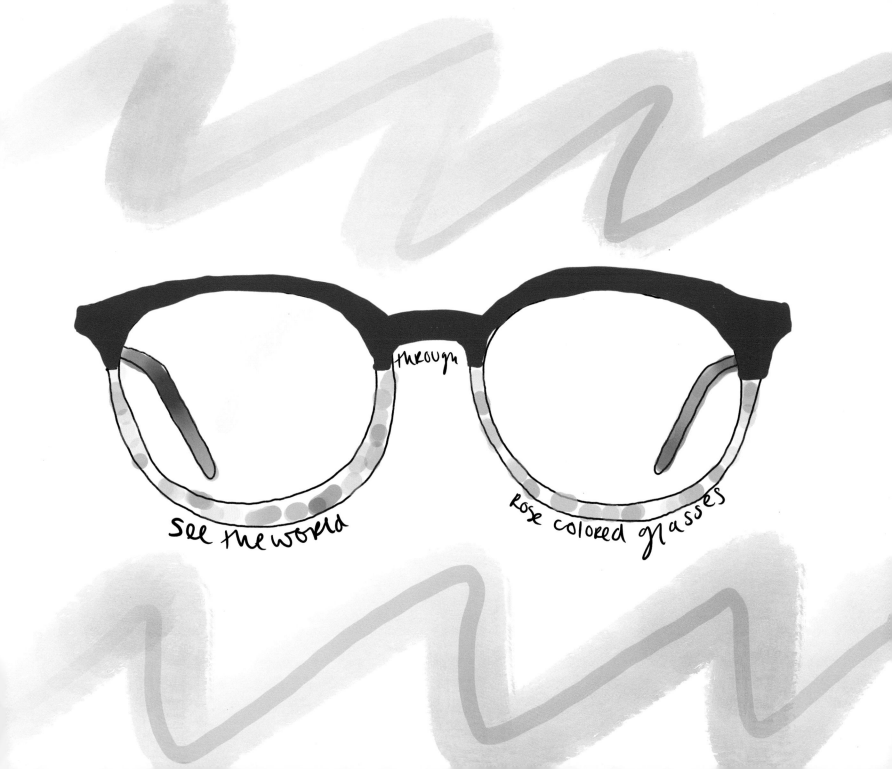

Hh

is for hat

h is for hat

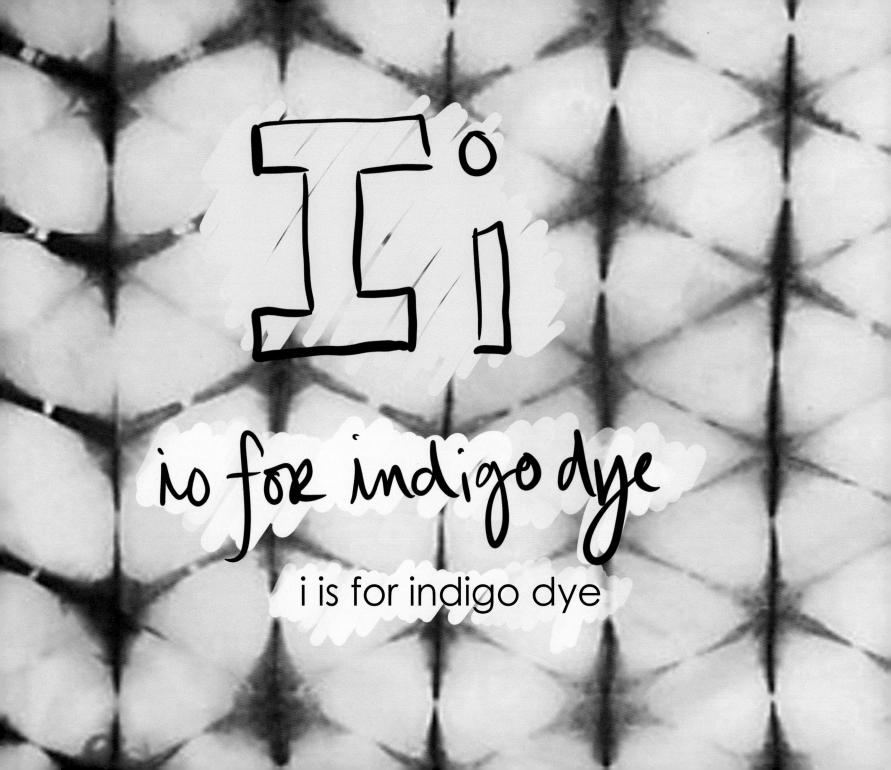

Ii

io for indigo dye

i is for indigo dye

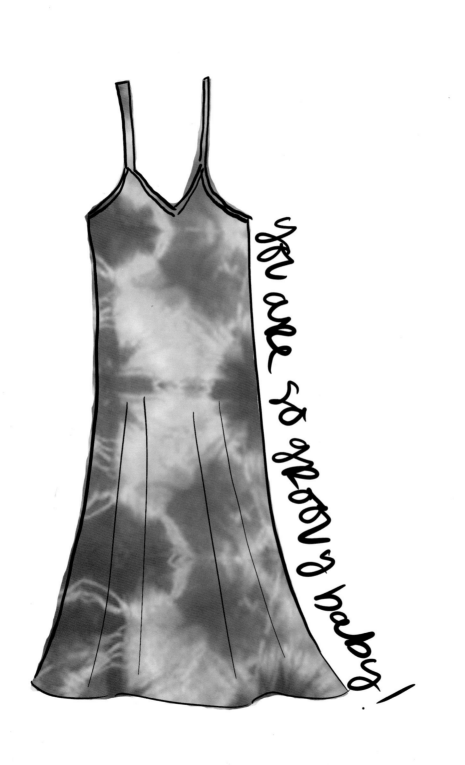

you are so groovy baby!

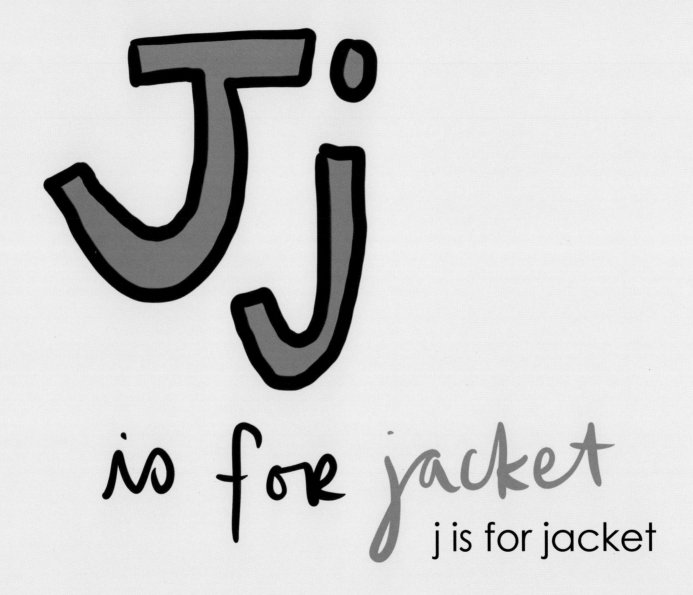

is for jacket

j is for jacket

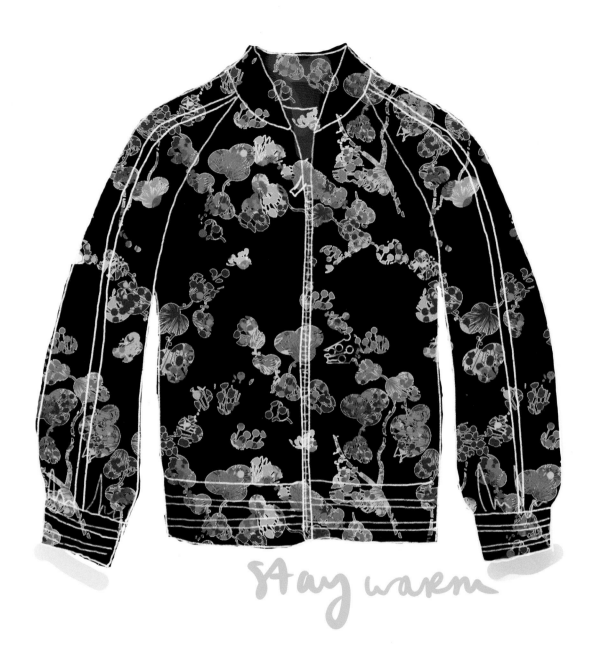

stay warm

Kk

is for kimono

k is for kimono

cover up

Ll

is for leggings

l is for leggings

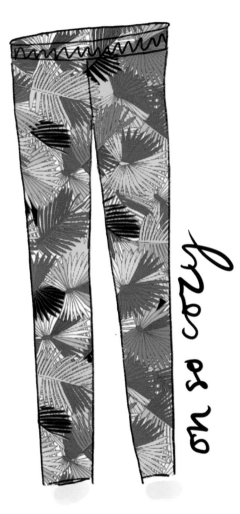

oh so cozy

io for measurement

m is for measurement

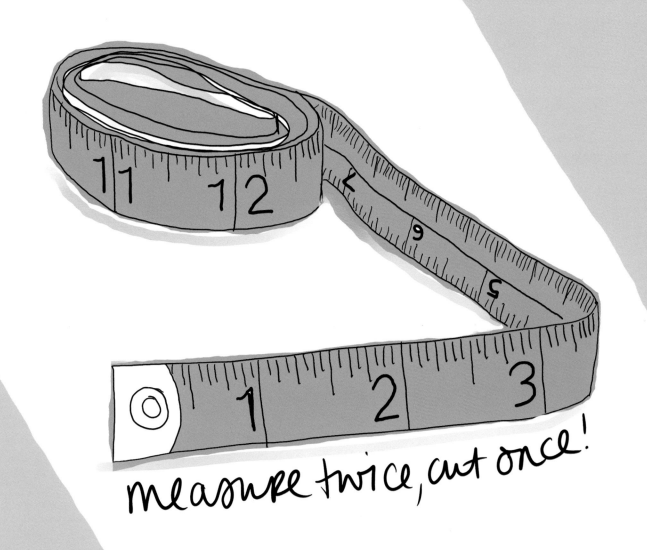

measure twice, cut once!

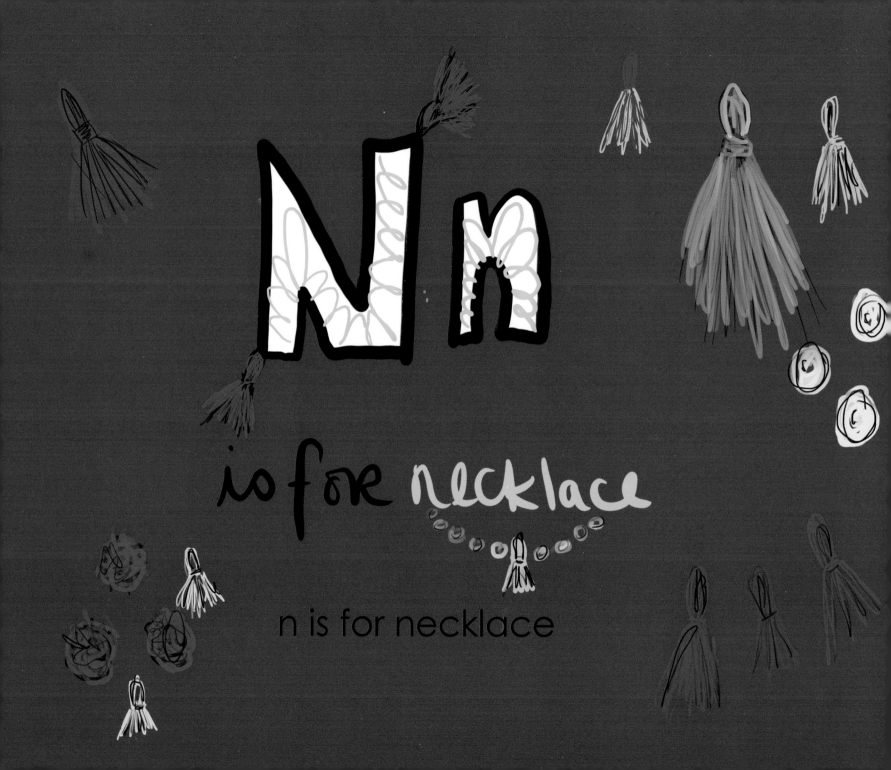

Nn

io for necklace

n is for necklace

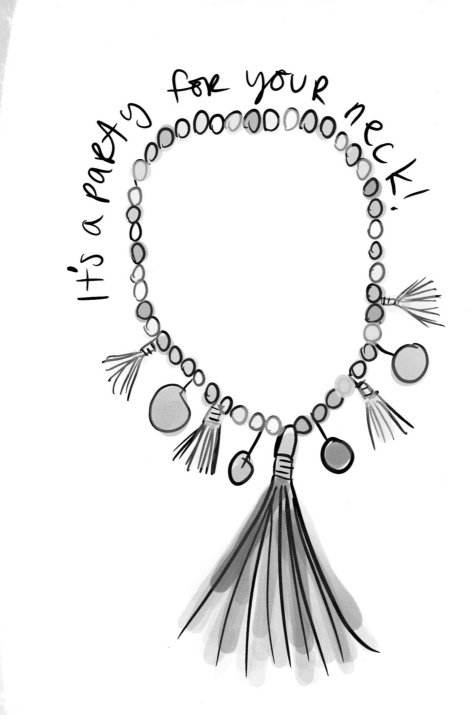

io for ombre

o is for ombre

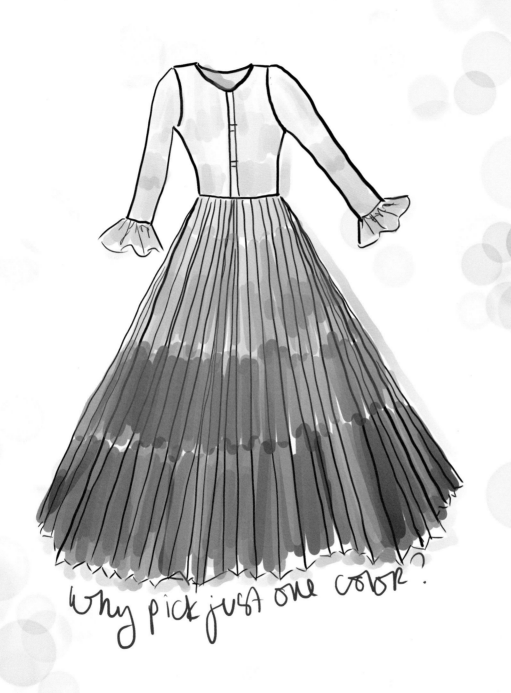

why pick just one color?

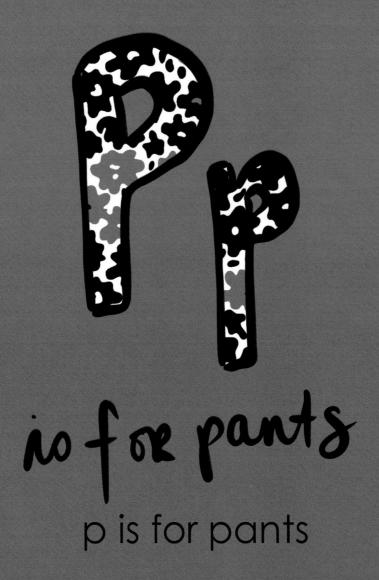

p is for pants

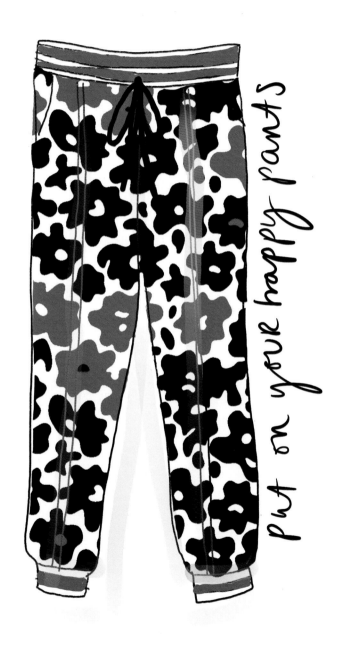

put on your happy pants

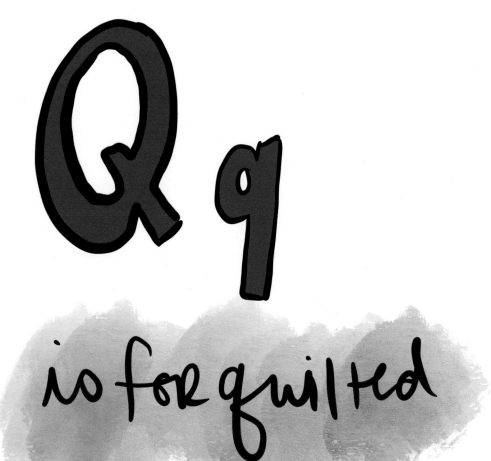

q is for quilted

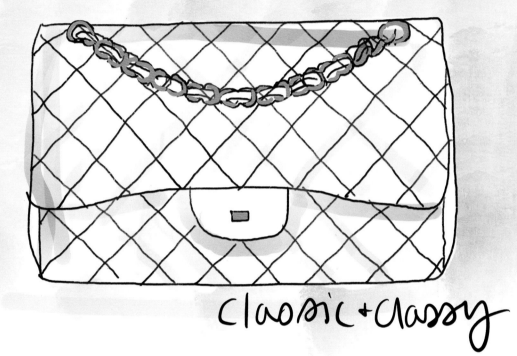

classic + classy

Rr

is for Rainboots

r is for rainboots

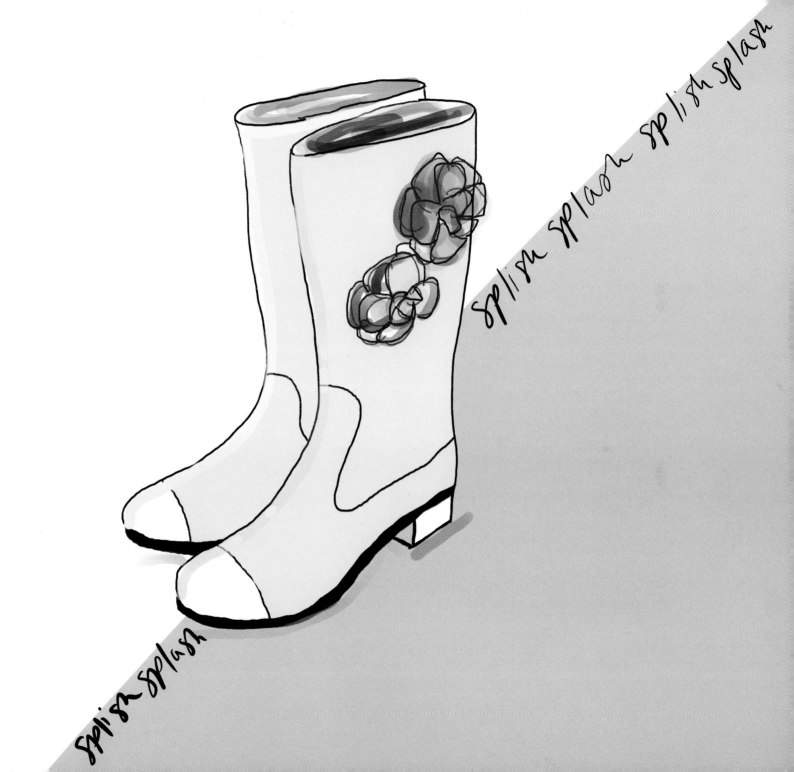

splish splash splish splash

splish splash

is for shoe

s is for shoe

Heels, platform, flat, wedge, boots, clog, pumps, sandals, mules, pumps, booties, pointy, round toe, metal, printed, colorful, tasseled, Athletic, running, over the knee, slides, patent leather, mary jane, ... en ... is, golf, ... to, high heels ... all! more shoes please!

is for tutu

t is for tutu

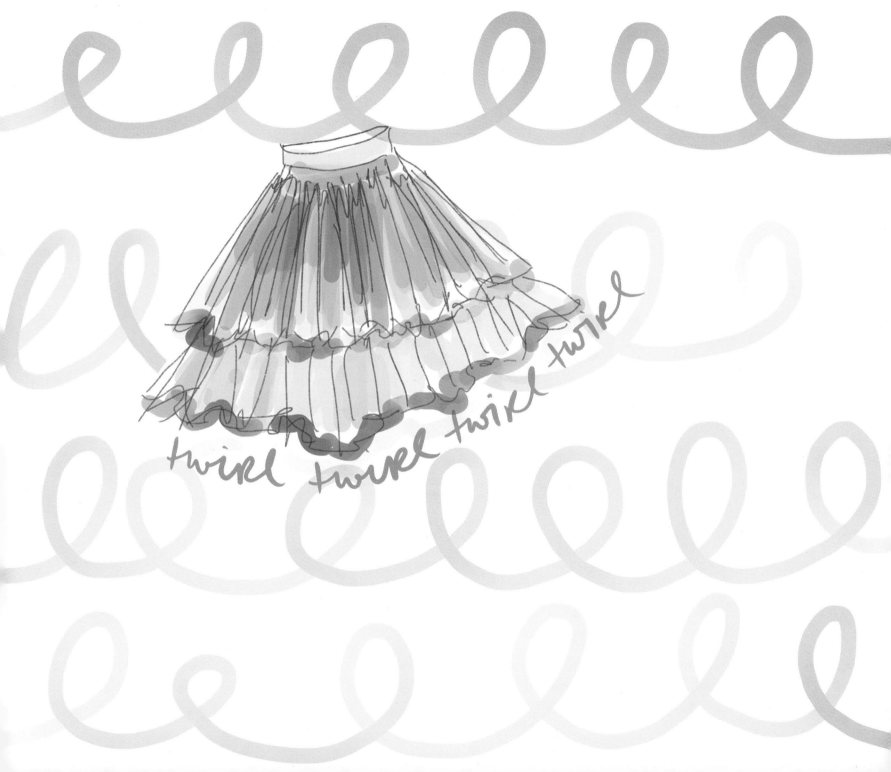

twirl twirl twirl twirl

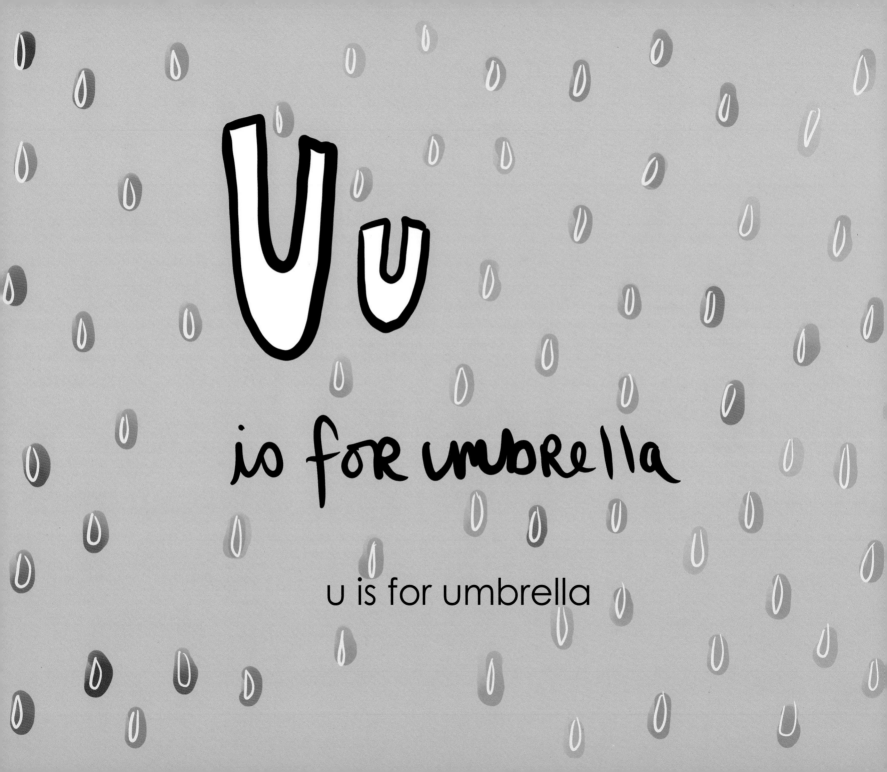

Uu

io for umbrella

u is for umbrella

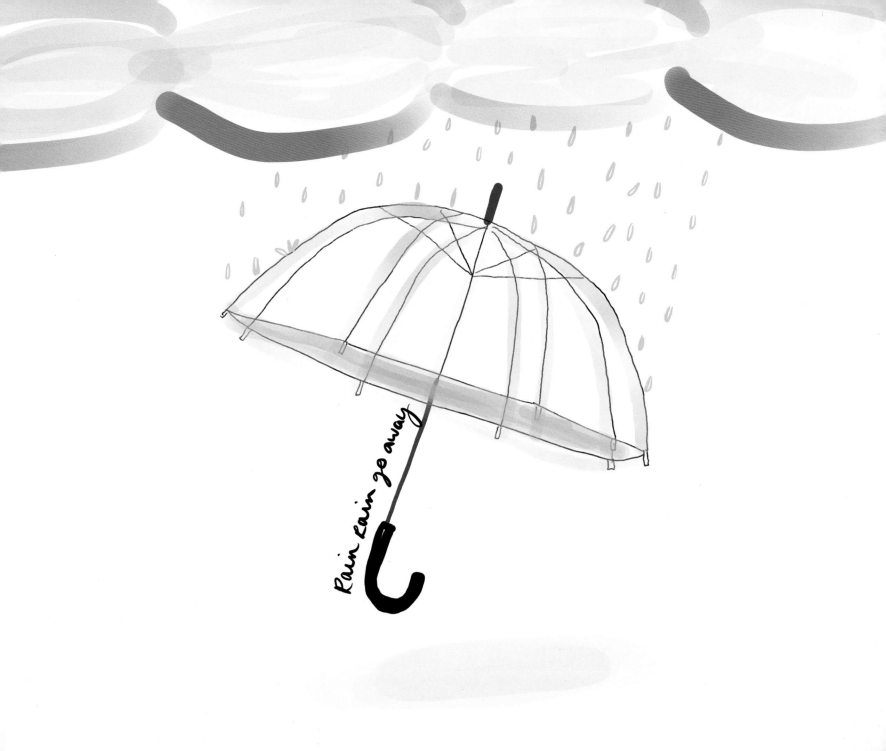

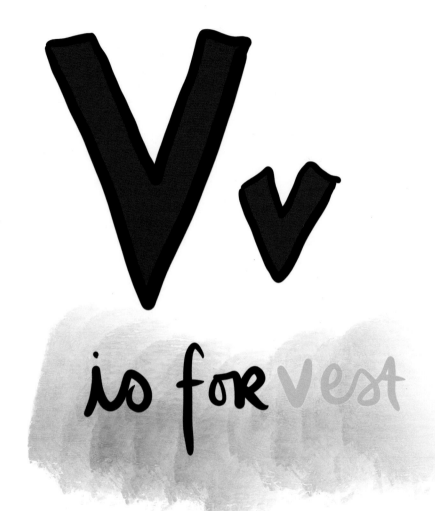

v is for vest

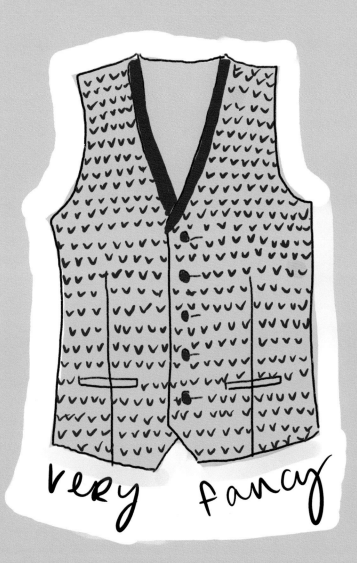

very fancy

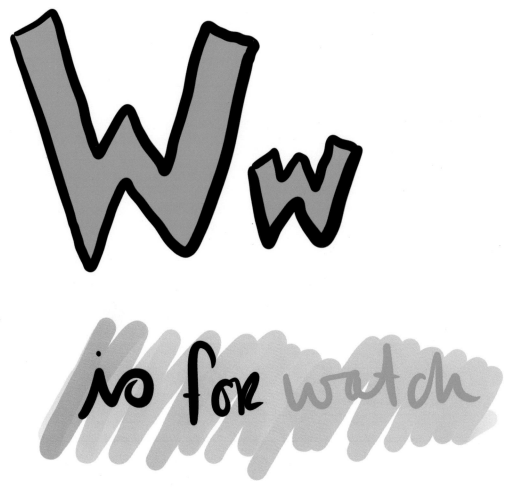

w is for watch

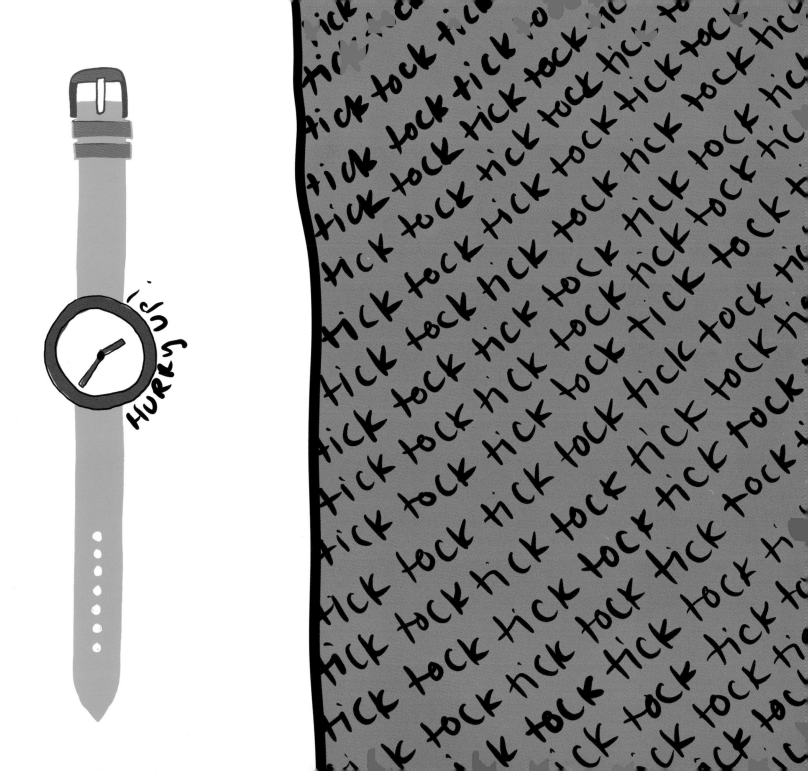

x is for sizes x-small - x-large

Kido size chart

XS

SM

M

L

XL

love the size you are! every size is beautiful!

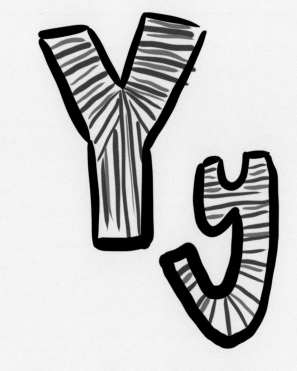

is for yarn dyed

y is for yarn dyed

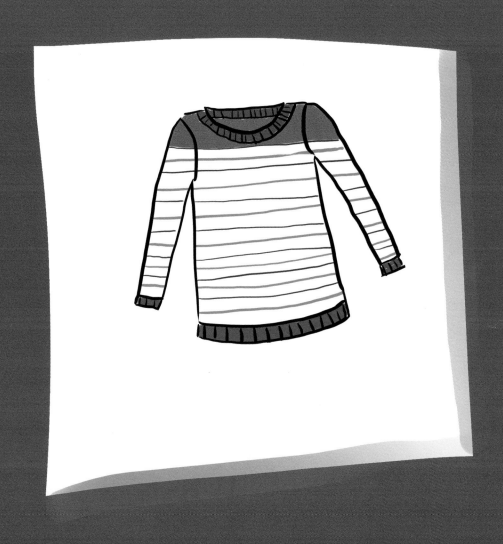

Stripes, oh so many stripes!

Zz

is for zipper

z is for zipper

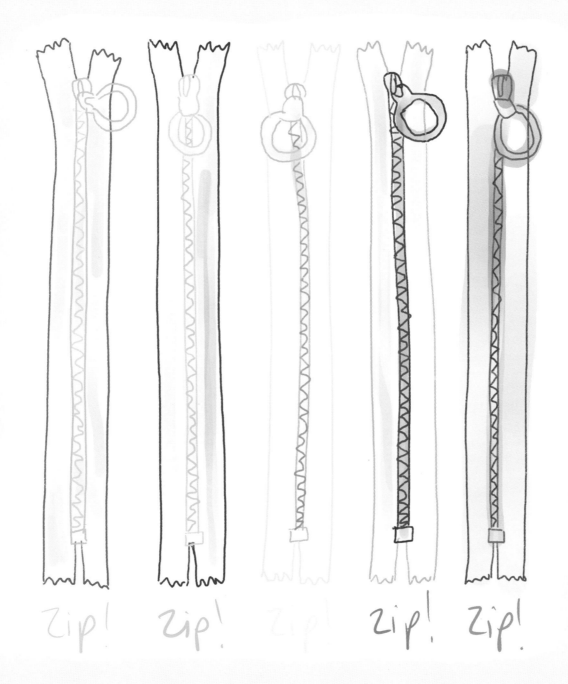

Zip! Zip! Zip! Zip! Zip!

Aa Bb Cc Dd Ee

Ff Gg Hh Ii Jj

Kk Ll Mm Nn Oo

Pp Qq Rr Ss Tt

Uu Vv Ww Xx Yy Zz

Now you know your ABCs, will you come design with me?

The End!

xx

ABOUT THE AUTHORS

AMANDA PERNA & SOLOMON STRUL are a husband and wife team. Amanda is a mom, wife & fashion expert who believes we are stronger together and life is too short not to follow your dreams! Amanda studied Apparel Design at the University of Alabama and FIT and designed for major fashion houses in New York before launching her own brands. She has appeared on internationally renowned TV shows and collaborated with some of the world's most well-known brands and retailers. Solomon is a father, husband & writer who loves to explore the world one word (and sometimes one letter) at a time!

For more information, please visit amandaperna.com or follow @theamandaperna.